T0083627

HANS PURRMANN

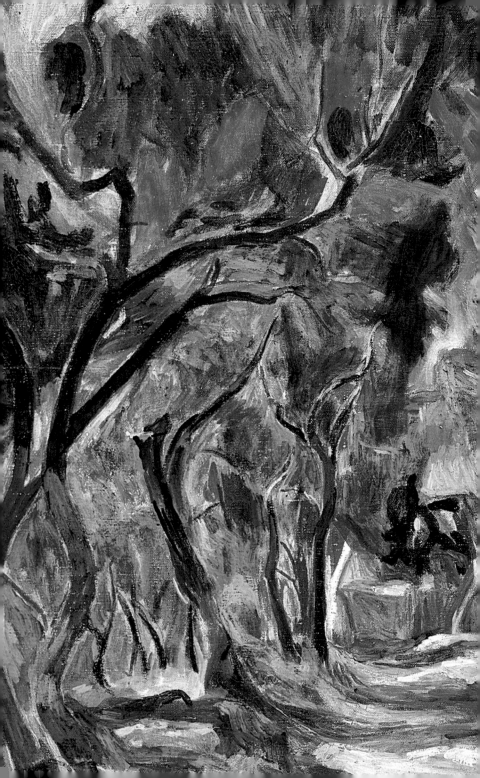

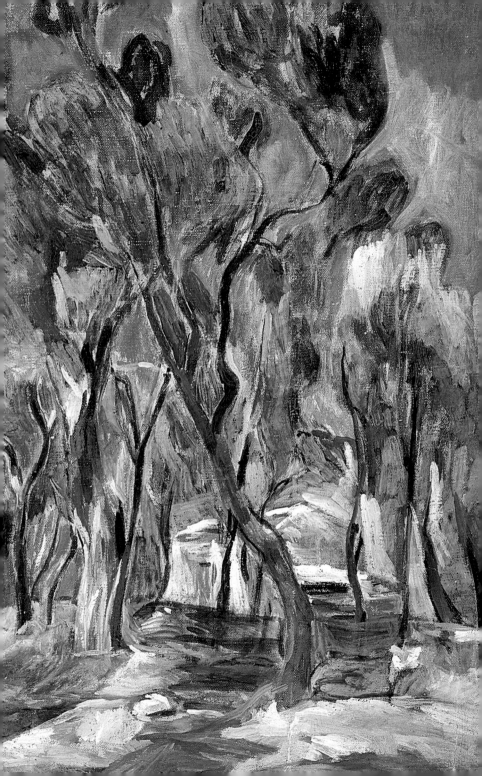

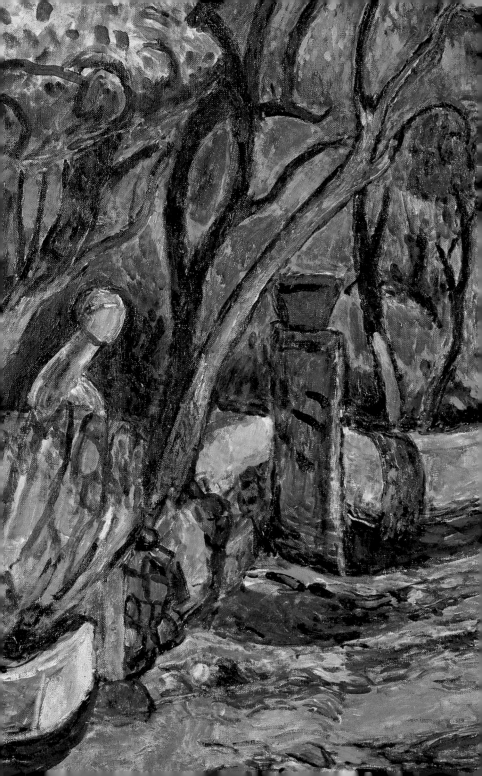

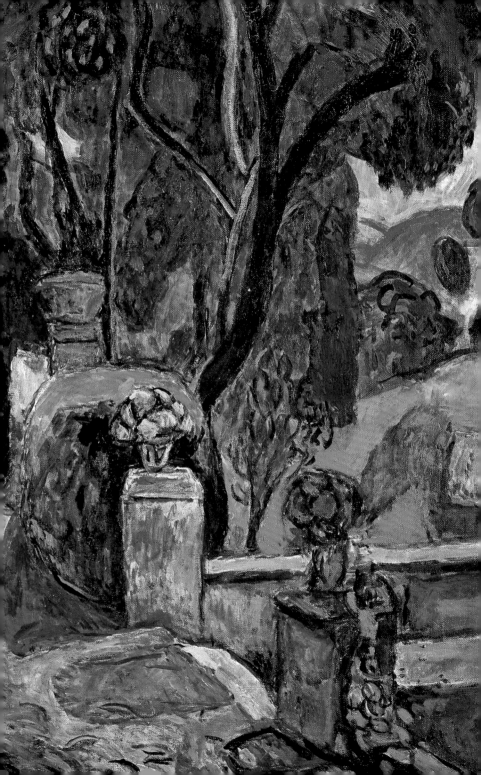

HANS
PURRMANN

Christoph Wagner

HIRMER

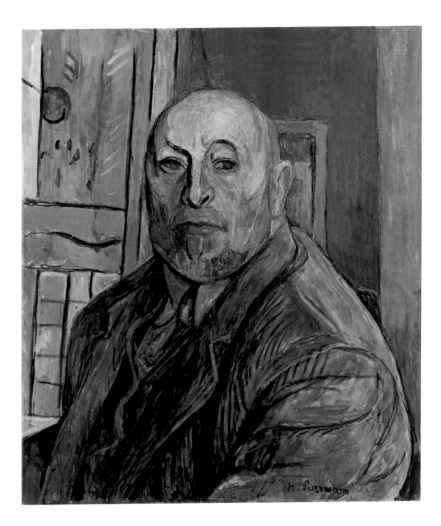

HANS PURRMANN
Self-Portrait, 1953, oil on canvas
Stiftung Saarländischer Kulturbesitz, Saarland Museum, Saarbrücken

CONTENTS

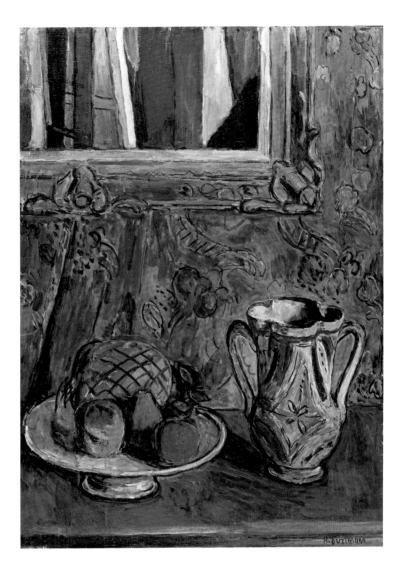

1 *Still Life with Fruit and a Vase*, 1955, oil on canvas
Landratsamt Bodenseekreis, Friedrichshafen

"ENGROSSED IN THIS NOBLE GAME" HANS PURRMANN AND HIS ART

Christoph Wagner

Without doubt, Hans Purrmann can be counted among the outstanding representatives of a classical position within twentieth-century Modernism.[1] He was also an artist who succeeded in not being compromised during the Nazi period. In 1955, his work was prominently represented with five large paintings when Werner Haftmann and Arnold Bode staged *documenta I* not only as the most important international forum for contemporary art of the post-war years but at the same time as an antipode to the barbaric National Socialist art of the Third Reich. His work is classical in that he adheres to the traditional art-historical genres of still life, interiors, landscapes and portraits. Classical, too, is the relationship between figures and space, the colouring and *peinture* Purrmann derived from Henri Matisse and Paul Cézanne. During his later years he played an active part in the discussions of representationalism versus abstraction which took place between the various avant-garde movements. And yet his painting cannot be simply situated between the two, or between tradition and avant-garde. Nor can he be solely labelled with the bold honorary title of the "German Matisse."

Fundamental to Purrmann's art is the impressive yet simple awareness that everything that painting makes visible has to be generated with colours. Purrmann was a colourist through and through, "engrossed in this noble game," as Hermann Hesse phrased it in a poem celebrating the artist.[2] Once we have understood this basic characteristic of Purrmann's painting, that everything his art shows is created from strong colours with values of their own, we can also recognise that Purrmann never used pure abstraction as a way to plumb his artistic imagination, for abstraction is already present in each of his brushstrokes. An outstanding example of this can be seen in his *Still Life with Fruit and a Vase* (fig. 1), which was exhibited at *documenta I*.[3] In a Baroque-framed mirror we perceive reflections of his easel, canvas and pigments as an almost abstract picture-within-a-picture. Here the reflection does not serve to duplicate the reality of the studio in the form of a trompe-l'oeil: it is an abstractly structured artistic field in which the actual objects are fragmented in painterly processes. We can study the close connection between the mirror motif and the theme of self-reflection on painting across the decades of Purrmann's career in continuous sequences. By including mirrors, windows, screens and frames he plots his own course between figuration and abstraction, revealing the structural realities of the picture and of painting by means of inversion and fragmentation. The adventure of his art begins when we follow the traces of pigments from his brushstrokes to the dimensions of the visible, which always manifest painting itself at the same time. This the curators of *documenta I* recognised when they decided to present Purrmann's painting among the possible positions of contemporary art.

BEGINNINGS AND STUDENT YEARS

Hans Purrmann determinedly put behind him his birthplace, the Palatinate's regional metropolis Speyer, and with it the confines of his father's painting shop, which as the first-born son he would have traditionally been expected to take over. Even so, he was encouraged in his studies and financially supported by his family for many years. Thanks to his father's gift of a craftsman-like introduction to painting at an early age and a supplemental training at Karlsruhe's school of arts and crafts (1895–1897), he was better prepared than other Academy students and could soon make

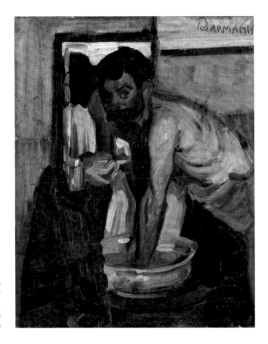

2 *Morning Toilet*, 1903
(previously dated 1902)
Oil on canvas, Purrmann-
Haus, Speyer (on loan
from a private collection)

his way in the art metropolises of his time, Munich and Berlin. In Franz
von Stuck's select Academy class, between 1897 and 1903, he studied along-
side Paul Klee, Wassily Kandinsky and Albert Weisgerber, and in 1904/05
he was accepted into the artist circles of the Berlin Secessionists gathered
around Max Liebermann. Purrmann promptly abandoned the previous
century's stylistic signature of chiaroscuro painting in order to explore for
himself the colouristic achievements of German Impressionism, a painting
style enriched by values and tonalities. The self-portraits and nudes among
his first paintings from the late 1890s show him to have been a young artist
with an ability to render highly varied flesh tones and with an equally
lively painterly grip on life: he was attracted neither by academic poses nor
by anaemic models positioned according to the classical canon, nor by
inherited stylistic charms. His interest lay in bodies shaped by daily hard
work and he rendered their signs of age unsparingly, yet in a distinctive
painterly manner. In his painting *Morning Toilet* (fig. 2), from 1903, Purrmann
experimented with a favourite subject of the French Impressionists and

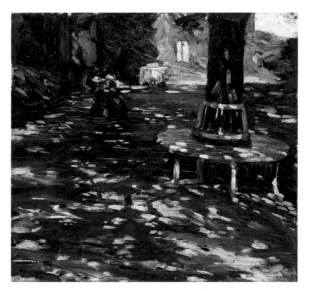

3 *Park in
Svinar*, 1903
Oil on canvas
Purrmann-Haus,
Speyer (on loan
from a private
collection)

x

structural elements from Japanese woodcuts in combination with vibrant
blue, ochre and red tones over grey. But here, too, he never abandons the
basis of an authentic art nourished by his own life experiences. The nude
male torso of a worker from Duisburg's Gutehoffnungshütte bending over
a wash basin[4] gave him the chance to develop within a stereometric picture
structure of mirror and wall panel – just as in the still life for *documenta I*
(fig. 1) decades later – a compositionally dense feast for the eyes. In these
years, an initial gloomy, oppressive chiaroscuro disappears from his land-
scapes as well. Inspired by Max Liebermann's work, during a trip with his
student friend Eugen von Kahler to the latter's family estate near Prague,
he investigated the rhythmic, dancing spots of light on the ground in the
painting *Park in Svinar (Sun Spots in the Park)*, from 1903 (fig. 3),[5] as a variant
of a late Impressionistic observation of nature. He also approached the art
of Max Liebermann, Max Slevogt and Lovis Corinth in his first large-
format *Seated Nude* (fig. 4), picturing a mysterious Polish equestrienne.
This was one of the main works he painted in Berlin in 1905 – to the dis-
may of his Munich teacher Franz von Stuck, to whom he showed the work.
In his rendering of this highly expressive woman we can see the extent to

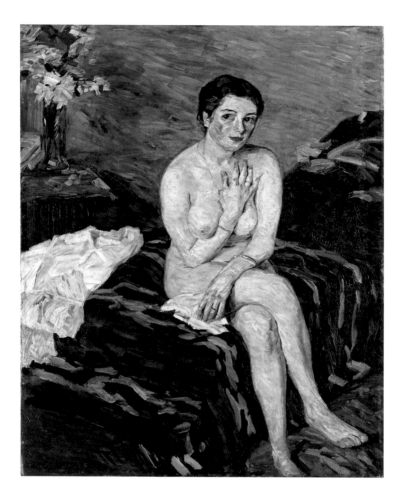

4 *Seated Nude ("Polish Equestrienne")*, 1905, oil on canvas
Purrmann-Haus, Speyer (on loan from a private collection)

which the lifelike flesh tones, the dynamic, vibrant brushstrokes, and not least the subtle disposition of space, developed from angled lines, contribute to her psychological characterisation. She has self-assuredly placed her white dress next to her on the divan, but has not removed her jewellery.

Looking back at this key work, Purrmann refused to reveal the name of his subject, only relating how much trouble the painting had given him: "For one larger work I found a lovely model in a Polish equestrienne, whom I painted life-size as a seated nude and who exhibited a rare patience, for I struggled with it, often led hopelessly astray by endless new impressions."[6]

"I BELIEVE IN GOD AND CÉZANNE"

Today it is hardly possible to judge what an artistic adventure it must have been for Purrmann when he arrived in Paris, the world capital of art, in 1905 without a particular knowledge of French and with extremely limited funds. During the following years Purrmann received decisive artistic stimuli in the city, both in his engagement with Henri Matisse as well as in his encounters and conversations in the later legendary Café du Dôme on Boulevard Montparnasse – and especially through his study of the art of Paul Cézanne.[7] From December 1905 he saw paintings by Cézanne in various exhibitions. Years before the painter was celebrated as the "father of Modernism" in Germany by Julius Meier-Graefe's monograph in 1910 and in 1912 on the occasion of the *Sonderbund Exhibition* in Cologne, Purrmann had discovered Cézanne for himself:[8] his artistic credo at this time, formulated with great emphasis, was: "I believe in God and Cézanne!"[9] His visit to the major Cézanne memorial exhibition at the Salon d'Automne in the Grand Palais in 1907 was a decisive experience. Cézanne's analysis of regular arrangements of colours as a "harmony parallel to nature," his blending of colour and form and his compositional construction of what he saw offered a new approach to painterly representation, and even more: a new way of seeing.[10] Purrmann also doubtless thought of Cézanne's art as a "Copernican revolution" in painting on the way to Modernism, in which a reflection on seeing itself could be incorporated in painting in a new way.[11] Purrmann shared these artistic passions with a young German painter, Mathilde Vollmoeller, a highly gifted artist who for some years had caused a stir in Paris: in exhibitions, in the Café du

5 *Standing Nude, Facing Right*, 1907
Oil on canvas, private collection

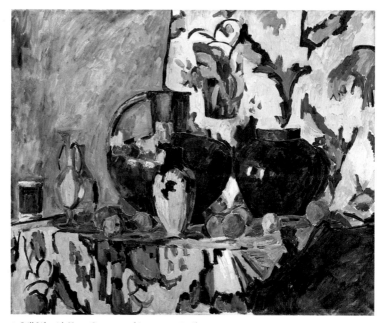

6 *Still Life with Vases, Oranges, and Lemons*, 1908, oil on canvas
Staatliche Museen zu Berlin, Nationalgalerie

Dôme and at the Académie Matisse. They eventually fell in love and
married in Stuttgart in January 1912.[12]

Like many other artists of this time, Hans Purrmann and Mathilde
Vollmoeller were convinced that in Cézanne's painting they saw timeless
principles of "pure art" reaching back to the beginnings of art history in
Egyptian culture. With Cézanne's conviction that the "modulation"[13] of
colour should take the place of modelling colour, for Purrmann colour
also took on new meaning as an independent visual tonal system: the unity
of colour and drawing and the aesthetic requirement to draw with colour
itself would accompany Purrmann through all the stages of his work. It is
instructive that, once again, it was in his depictions of nudes and his still-
life paintings that Purrmann realised these fundamental lessons of French
art. In the painting *Standing Nude, Facing Right* (fig. 5), which he painted at
the Académie Colarossi in 1907, he shed his indebtedness to the German

Impressionists and deliberately turned towards a liberation of colour inspired by Matisse and Cézanne, together with a use of complementary colours to which he gave his own painterly signature from the beginning. Purrmann's painting *Still Life with Vases, Oranges, and Lemons* (fig. 6), from 1908, can be considered a consummate, almost somnambulistically confident adaptation of these new ways of structuring with colour and exploiting the possibilities of a planimetric, balanced picture composition.

AT THE SIDE OF HENRI MATISSE

From 1908, Purrmann was also in close personal contact with Matisse and his family. The two men made several joint trips to Germany and southern France.[14] Purrmann would serve as co-founder and chairman of the private Académie Matisse.[15] His depiction of the *Coastal Landscape near Cassis* (fig. 7), which he painted alongside Matisse, illustrates – beyond the painterly stimuli from the older man – Purrmann's independent view and his particular ability to open up spatial depth in his compositions. This sets him apart from the more ornamental, flat compositions in the art of Matisse. Purrmann had no need of dramatic themes or historically important subjects. In 1910 the still-unplanted beds in front of Matisse's studio villa in the Paris suburb of Issy-les-Moulineaux were enough to inspire his *Path in Matisse's Garden* (fig. 8), in which he discovered a new way of painting of his own. Naturally, in his search for the simplicity in nature, developed in spirited brushstrokes, he not only incorporated the methods of Cézanne and Matisse, but also certain features of the French Impressionists. Yet with the grey values of the sky and decidedly earthy tones of the ground, in this view of nature Purrmann struck a distinctly personal note without negating his origins. At the same time, this work, with its energetic, liberated brushstrokes and pulsating traces of colour, shows that the young painter had completely absorbed the lessons of Matisse's practice of enlivening autonomous colour in a variety of

Following double page:
7 *Coastal Landscape near Cassis*, 1908, oil on canvas, private collection

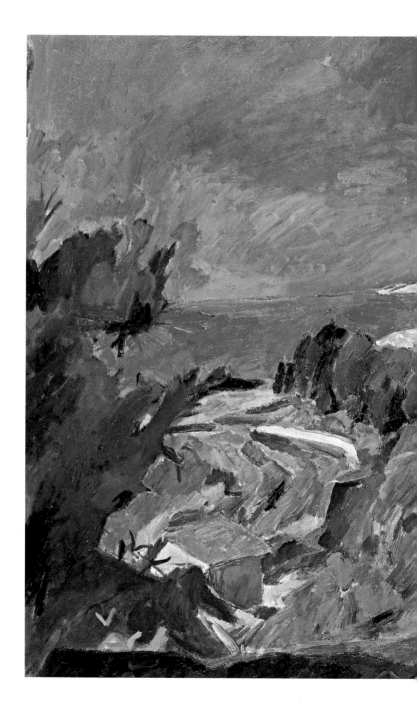

8 *Path in Matisse's Garden*, 1910, oil on canvas, private collection

rhythmic, ornamental relationships between brushstrokes – the *rapport* so crucial to Purrmann – and made it his own.

It was also Matisse who inspired Purrmann during these years to undertake what was apparently his only "excursion into sculpture."[16] At the Académie Matisse he produced plaster sculptures between April 1909 and March 1910, like the *Striding Man* and *Standing Woman with Hanging Arms* (figs. 9, 10), which demonstrate that he was not only an important painter, draughtsman and graphic artist,[17] but also a gifted sculptor. It is typical of Purrmann's eventful life that after an odyssey through the French art market, these sculptures came into the artist's possession once again in 1958 by way of the painter Simon Levy, nearly half a century after they were made. Only many years later, after his death, were they cast in bronze. As for Matisse's appreciation of the younger man's work, it is revealing that in 1964 the elderly painter claimed that Purrmann's painting *View Towards*

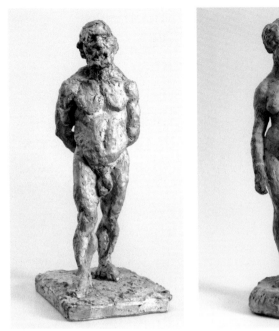

9 *Striding Man*, 1908, plaster
Height 68 cm, private collection

10 *Standing Woman with Hanging Arms*
c. 1909/10, plaster, height 65.5 cm
Private collection

Collioure (fig. 11), painted on a trip the two artists took to the Mediterranean in 1911, was in fact his own, and even signed it. Although that signature was removed long ago, the incident clearly shows how highly Matisse continued to regard Purrmann's painting, even at an advanced age.[18] Purrmann in turn remained loyal to Matisse all his life, and to the principles of a rule-based French art that for all its painterly elan and spirit was also "measured, matter-of-fact and committed to academic concepts."[19] As the art historian Friedrich Rintelen aptly noted as early as 1925, one of the special qualities of Hans Purrmann's art is the fact that it adheres to artistic themes reaching far back, to academic pictorial and genre traditions like the still life, interiors, landscapes and portraits.[20] In his theoretical convictions Purrmann also adhered to these lines of tradition in French art, whose "artistry, down to the most minor of artists [employs] an atelier jargon and a rich workshop vocabulary and the clearest professional defi-

11 *View Towards Collioure*, 1911, oil on canvas, private collection

nitions of pictorial concepts and pictorial elements that are unknown or hardly familiar to our German artists."[21] All his life Purrmann remained committed in his aesthetic judgement to such key concepts of French art theory as "peinture," "ensemble" and "rapport," and artistic principles like order, unity and harmony.[22]

"... PARIS WAS THE ONLY THING THAT COULD RESCUE ME AND LEAD ME FORWARD"

Purrmann had set himself apart from the positions of German Expressionism early on. Like Matisse, he looked askance and unimpressed at artists "wishing to be modern" and the "wildest Modernisms."[23] He was well aware that the "Expressionist impulse" could appear in highly different artistic concepts, pictorial forms and genres. The young Hans Purrmann even seems unusually mature in standing aloof from the debates of the major avant-garde movements, and speaking loftily of himself as a "late comer" in the artistic constellation of the first half of the century; "unlike the German Expressionists," he wrote, "[he] could not commit to a necessary and declared opposition" to the "three strongest painters: Liebermann, Corinth and Slevogt". In order to "take a new, independent path," "Paris was the only thing that could rescue me and lead me forward."[24] Even though Purrmann was not called up for military service in 1914, with the outbreak of war he not only lost Paris, his chosen artistic and spiritual home, but also his art collection and other possessions, among them the above-mentioned plaster sculptures, when his Parisian apartment and its contents were sequestered. What is more, owing to the nationalistic, revanchistic "hereditary enmity" between France and Germany, he was promptly branded a "would-be Frenchman," and referred to as a "German Matisse." We now know that Purrmann's efforts to make Matisse better known in Germany were by no means as fruitless as he himself complained in retrospect, but he experienced his failures in this respect as a personal warning.

12 *Frame Houses (Castle Path II)*, 1914, oil on canvas
Heidi Vollmoeller-Stiftung, Vaduz

BEILSTEIN, BERLIN AND LANGENARGEN

From 1914 to 1916 the Purrmanns, now with a two-year-old daughter and an infant son, took refuge from the tumult of war at the Vollmoeller family's country seat, Burg Hohenbeilstein, near Heilbronn. One of Hans Purrmann's paintings from that time, *Frame Houses (Castle Path II)* (fig. 12), with houses nestled in an autumn landscape, evokes the spirit of the place. In 1916 they returned to Berlin, the vibrant art metropolis, where they lived until 1935. From 1919, however, they spent their summers in Langen-argen, on Lake Constance, where they had bought an idyllic fisherman's house. The spot is frequently documented in his painting, as in *Purrmann's House in Langenargen*, from 1929 (fig. 20). Between 1922 and 1927 there

13 *Path Through Olive Trees*, 1922
Oil on canvas, private collection

were also sojourns in Rome and elsewhere in Italy that were important for his artistic development; they reawakened his love of Mediterranean colour and light effects, his painterly *italianità*. In paintings like *Path Through Olive Trees* (fig. 13), from 1922, Purrmann reignited in the light of Sorrento a Fauvist, sun-filled atmosphere in the strongest of complementary colours.

Along with portraits, still lifes, nudes, cityscapes and landscapes, he painted a large number of important interiors and atelier pictures in Berlin and Langenargen that stand out as key works within his oeuvre (figs. 14, 15, 18, 19). In them he documented his surroundings, the places where he worked and familiar objects. He would gather the latter and frequently arrange them artistically before starting to paint. Among them were recent and older paintings, textiles, vases, pieces of furniture, mirrors and carpets. In these paintings Purrmann develops a complex discourse within the picture of painterly and artistic self-assurance, packing into the picture frame a number of "pictures within a picture" and reflecting on his artistic progress on various levels during the process, as in *The Artist's Studio*, from

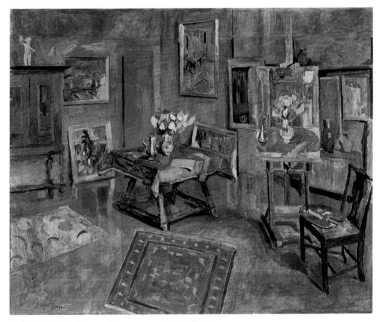

14 *The Artist's Studio*, 1917, oil on canvas, private collection

1917 (fig. 14). In this work, on the easel stands another painting he was working on at the time, *Floral Still Life with Silver Pitcher*, from 1917, whose actual subject can be seen on the nearby table. This still life also incorporates a landscape painting; thus various levels of reality are tumbled together kaleidoscopically, not necessarily reflecting their actual location: the red door that is closed in the interior appears in the picture-within-a-picture as opening into an adjacent room. By creating these disjunctions between the reality and the painting, Purrmann not only calls into question the painting's realism, but also calls attention to the process of a painterly construction of reality. His palette has been placed on a chair during a pause in his work. Through the radiant ornamental structures of the two carpets and the tablecloth as well as the expressively monotone red studio door, the artist has woven additional colour accents into his complex composition of intra-pictorial relationships. The entire interior appears to have been transformed into painting under his hand. The

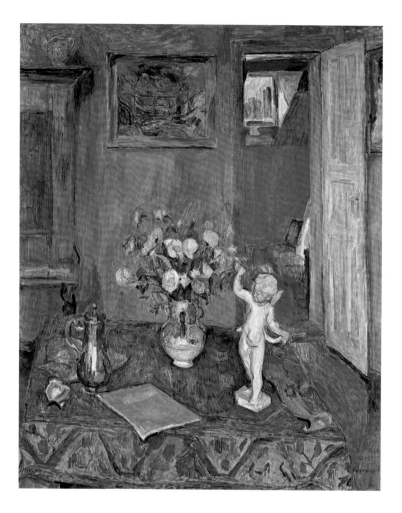

15 *Interior with a Bouquet of Flowers and Putto*, 1918
Oil on canvas, private collection

painting's different degrees of reality, its spatial construction, its painterly reflection of the artist's perceptions – all these invite the viewer into a never-ending game. In this game of an illusion of reality produced by painting, all the visual dimensions exist only as painting, so that the painter himself, indeed his painting, retains the upper hand. Just when we comprehend that the entire picture as a painting not only reflects Purrmann's Berlin atelier, but that he himself is present as a painter at his easel, both in the easel painting as a picture-within-a-picture and in the palette placed in front of it, do we become aware of the artistic reflection in which Purrmann ensnares us. It is an instance in which seeing, translation, iconographic and pictorial traditions down to the reference to *pictura* allegories and painting as process appear inextricably interwoven.[25] In other works, like the *Interior with a Bouquet of Flowers and Putto* (fig. 15), Purrmann enters into artistic competition with the genre traditions of older art, here seventeenth-century Dutch interior painting, which he wholly transforms into his own expressive, glowing colours. In his work there is always the engagement with what painting can achieve with respect to reality. The painterly process itself is present in the deliberately sketchy painting style.

Purrmann confessed in retrospect that he liked to paint while looking at familiar things "preferably ... from his bed." His friend Gotthard Jedlicka related that Purrmann loved to picture the world "in a state of calm or unhurried flow: above all the life that circles on itself in things and objects."[26] Family members and friends who watched Purrmann paint also unanimously report that he not only painted most of his paintings "from nature," but also finished them there.[27] The *longue durée* of an artist's occupation with his own perception that Cézanne introduced into art history as an artistic ethos lives on in Purrmann's art. Calm in the contemplation of his motif is also seen in a painting like *Female Nude Seen from the Back before a Mirror*, from 1919 (fig. 16). The apparently so fleeting motif of a woman arranging her hair is concentrated in the interplay of the arms, the picture frame, the mirror and its reflection of a screen. In the *Portrait of the Artist's Daughter Christine* (fig. 17), from 1923/24, which pictures her at the age of eleven during a pause in her reading, Purrmann uses the geometrical and floral ornaments of the chair and the surrounding space with their complementary colours to develop a composition that regulates every element, one that appears to be governed by the horizontal and

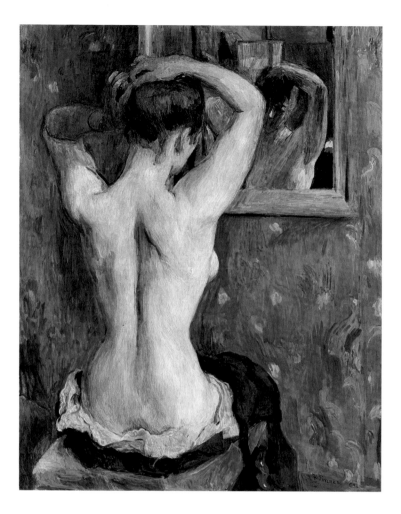

16 *Female Nude Seen from the Back before a Mirror*, 1919
Oil on canvas, private collection

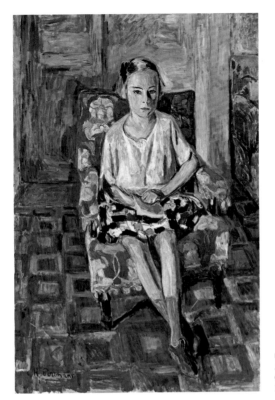

17 *Portrait of the Artist's Daughter Christine*, 1923
Oil on canvas
Private collection

vertical axes of the girl's face. In *Interior with a Girl in a Deck Chair* (fig. 18), from 1918, his daughter, now almost sixteen, is again seen reading, this time in his studio in Langenargen. Purrmann transports us into the relaxed, summer-like atmosphere of Lake Constance, providing a subtly inviting, multilayered visual experience with the open window, the interplay of the colour planes of the interior, the interactions of such elements as the mirror, the view out of the window, the screen with its own ornamental design of landscape and plants as well as the reflections in the mirror and the window panes. The girl in the deck chair is seemingly engrossed in her own world and takes no notice of these visual stimuli, with the result that Purrmann conveys the charming illusion that what he is showing us is life itself, although he does not belabour the fact that it is always his painting

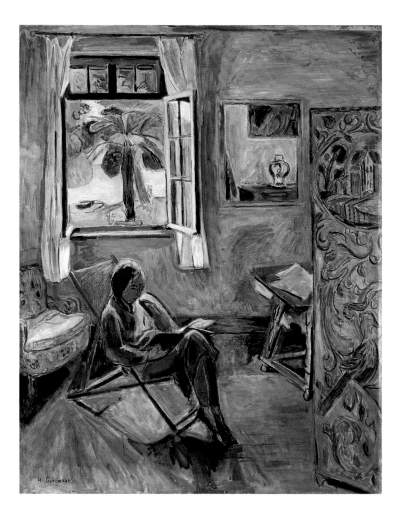

18 *Interior with a Girl in a Deck Chair*, 1928, oil on canvas
Stiftung Saarländischer Kulturbesitz, Saarland Museum, Saarbrücken

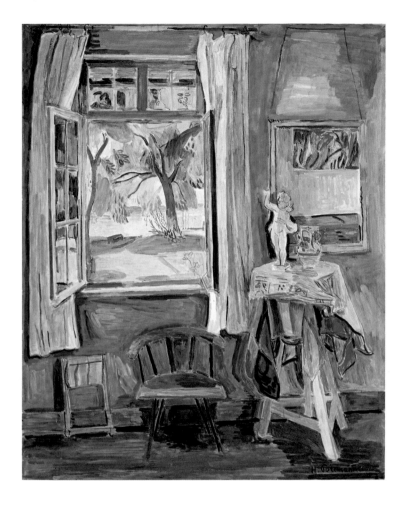

19 *The Artist's Studio in Langenargen*, 1927, oil on panel
Städel Museum, Frankfurt am Main

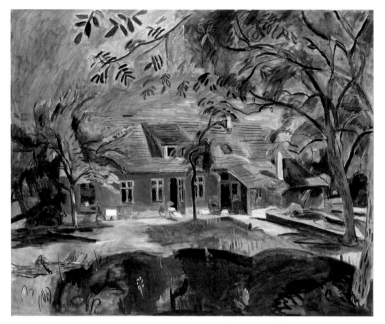

20 *Purrmann's House in Langenargen*, 1929
Oil on canvas, private collection

that provides such impressions. In Purrmann's work we thus repeatedly encounter a new painterly approximation of reality, the most complex entanglements between seeing and the realm of the visible. Paul Cézanne's concept of the *réalisation* of a picture – the transformation of the painting into the act of seeing itself – is demonstrated and kept alive here in a specific way. Hans Purrmann aims in his painting for such *réalisation* in all genres and with a uniform intensity, exploring the boundaries and relationships in what he sees. And remarkably, in each of his paintings of a particular interior, as in his painting *The Artist's Studio in Langenargen* (fig. 19), from 1927, he provides a painterly reinterpretation of the space and the network of relationships between its objects, forms and subtle gradations of colour.

Despite extensive archival research, it is still not altogether clear[28] to what fortuitous coincidences and personal networks Hans Purrmann owed his appointment to the directorship of the Villa Romana in Florence in October 1935. Or how he managed to retain it until 1943, in defiance of the National Socialists' increasingly thorough surveillance and "*Gleichschaltung*" of institutions of cultural policy. As early as 1932, before Hitler's takeover, he had become a target of right-wing and National Socialist attacks in the uproar over his wall painting *Allegory of Science and the Arts* in the Council Hall in Speyer. And on 1 August 1939, the Italian branch of the Nazi Party attested in a letter to the German Embassy in Rome that Purrmann was a "proponent of an altogether un-German concept of art."[29] Even so, in 1940 the Villa Romana Association was still able to offer Purrmann an extension of his contract. Other documented events in these years illustrate the dedication with which Purrmann and his wife fought to defend tolerance for artists who failed to conform to Nazi cultural policy. As early as 1933 he had stood up for persecuted artist colleagues at great personal risk. At that time the German-Swedish graphic artist and caricaturist Thomas Theodor Heine, hunted by the Nazis because of his illustrations for the satirical journal *Simplicissimus*, found sanctuary in the Purrmanns' Berlin apartment for weeks and the couple even provided him with forged travel documents they produced themselves. It is a pity that these are not included in Purrmann's catalogue raisonné![30] In this context it is not surprising that Purrmann's art was also shown in the *Degenerate Art* exhibition in 1937. And in the following years, a total of 45 works of his were confiscated from museum collections in Germany. That the Nazis viewed him with suspicion is evident from the fact that he was interned for the duration of Adolf Hitler's visit to Florence in 1938. It is largely thanks to Purrmann and his efforts during eight difficult years that the Villa Romana, founded by Max Klinger as an independent artists' forum in 1905, survived these tumultuous times as a safe haven for contemporary art, uncorrupted by the National Socialists.[31] Werner Haftmann, then serving as an assistant at the Kunsthistorisches Institut in Florence, has related how Purrmann set about creating an "aura of art around himself at Villa Romana, the way a snail builds its house": "The four-room apartment

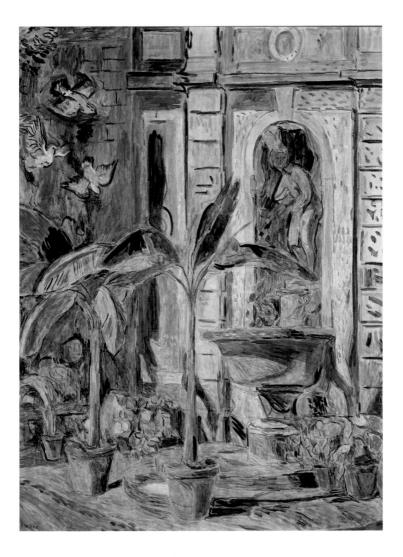

21 *The Fountain at the Villa Romana,* 1937
Oil on canvas, private collection

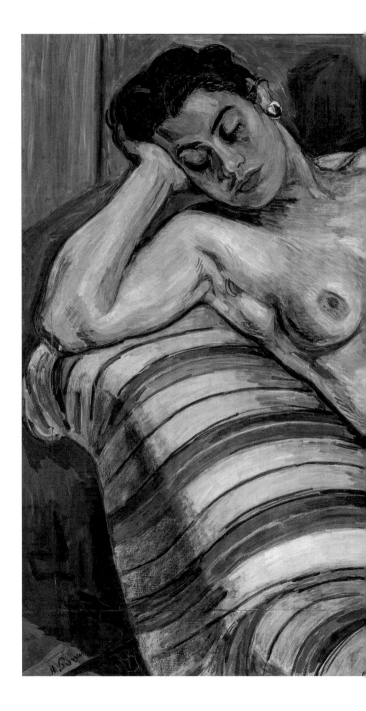

on the ground floor of the Villa Romana was filled with exquisite treasures of the most varied provenance. Near a small Renoir there were marvellous Persian tiles; right next to a Cycladic sculpture you could see Coptic fabrics, and next to Greek terracottas were Persian and Indian miniatures. He loved the old fabrics and vessels we see in many of his pictures. [...] They were always present as defining features of his environment."[32]

In their motifs Purrmann's paintings from this period also reflect the self-contained atmosphere of the Villa Romana, with its forty rooms and 15,000-square-metre garden, as a refuge and a fragile paradise. The painting *The Fountain at the Villa Romana*, from 1937 (fig. 21), is but one of the 37 oils in which Purrmann documented the Villa Romana. It pictures the villa's forecourt ringed by potted palms and flowers, with its Venus Fountain framed by rusticated, neoclassical architecture. Doves are fluttering in from the upper left. Everything is bathed in the southern Italian light and the warm ochre tones from which Purrmann developed his nuanced composition. Here a world, steeped in classical antiquity and the Renaissance, is seemingly untouched by the grim realities of the time, transformed into a cheerful evocation of the painter's life.

Purrmann's numerous still lifes, portraits and nudes also contain no indication that the world outside is so cheerless. It even appears that he was defiantly denying this fact in paintings like the large-format *Recumbent Nude*, from 1940 (fig. 22). The work focuses on the obvious eroticism of his curvaceous model in the ornamental interplay of the curves of the divan and the tapestry. Although we do not know the model's name, she appears to have been a self-assured woman fully aware of her physical charms, which are doubtless accentuated in the painting. This is what constitutes the work's modernism: Purrmann was deliberately picturing a female nude of flesh and blood as opposed to a timeless, idealised, mythological Venus figure. Haftmann reports that Purrmann hung this painting in the ground-floor living room of the Villa Romana "as an altogether deliberate provocation," intended to shock "the eyes of his bourgeois or even official visitors."[33] Purrmann painted four different versions of this nude motif,

Previous double page:
22 *Recumbent Nude*, 1940, oil on canvas, private collection

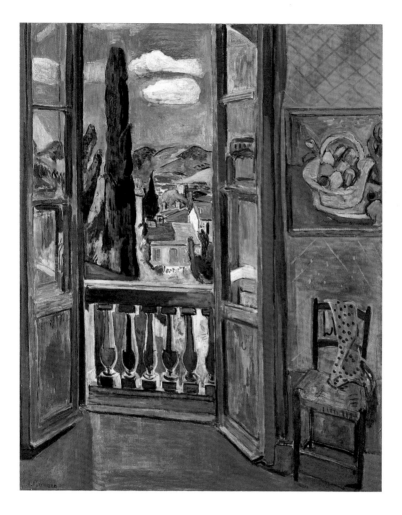

23 *View from the Villa Romana*, 1940
Oil on canvas, private collection

which seems to have been of emblematic significance for him, the last one in the early 1960s.[34] In his painting *View from the Villa Romana* (fig. 23), created in the same year or perhaps as early as 1937,[35] he celebrates the Villa Romana's surrounding landscape as a feast for the eyes, in almost unreal, euphorically exalted complementary colours. In its composition he skilfully combines resolutely flat colours for the most varied features of the scene, prefiguring his use of colour in his late years. The flat reddish purple of the floor, the cool blue-green of the walls and the shades of blue, white, green and yellow in the view out of the window, the reflections in the balcony doors and the still life of fruit, integrated as a picture-within-a-picture, are perfectly balanced. On trips to Castiglioncello, Siena, Lerici, Trento and Fano he painted further pictures. Only in a few paintings can we sense the menacing situation of the time in the severity of the drawing and in the perception of himself, as in a self-portrait from 1940, known only from a photograph.[36]

In 1943, Purrmann suffered a number of fateful blows within only a few weeks. On 16 July his wife Mathilde died in Munich; she had been ill for a long time, but her death still came as a shock. And a short time later, his living situation in Florence was unexpectedly overturned. That autumn he was forced to flee from Florence and Italy and take refuge with relatives of his deceased wife in Switzerland. Once again, with the Villa Romana he had lost not only the focus of his recent painting, but also large portions of his works and possessions.

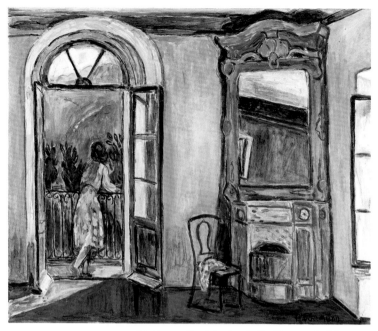

24 *Hermann Hesse's Apartment with a Woman on the Balcony*, 1951
Oil on canvas, private collection

A NEW HOME IN MONTAGNOLA

In 1948, after lengthy sojourns in Castagnola, near Lugano, and in the Hotel Bellevue in Montagnola, at the age of 68, Purrmann found a new home for himself and his painting in the Casa Camuzzi in Montagnola, on the Collina d'Oro above Lugano. It was a stroke of luck for his late artistic work that he learned of the place from the textile artist and tapestry weaver Maria Geroe-Tobler. He would live there up until his death in 1966. Over time, the historic palais, built around the middle of the nineteenth century by the Ticino architect Agostino Camuzzi, would shelter a number of well-known artists, composers and writers, among them Thomas Mann, Martin Buber, Karl Hofer, Georg Meistermann, Peter Weiss and Hermann Hesse, and in this regard, it was not unlike the Villa Romana. Purrmann celebrated the genius loci of this spot, steeped in art and literature, in a number of works, for example *The Summer House at the Casa Camuzzi*, a view of its

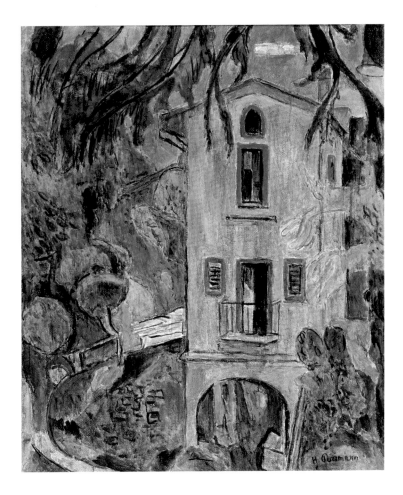

25 *The Summer House at the Casa Camuzzi*, 1952
Oil on canvas, Städisches Museum, Simeonstift, Trier

exotic terraced park (fig. 25). In 1950/51 he painted a series of ten interiors picturing the room in the Casa Camuzzi that Hermann Hesse had occupied between 1919 and 1931 and immortalised in his story *Klingsor's Last Summer* (fig. 24) from July 1919.[37] That Purrmann wrote of the room's "little Klingsor balcony" in a letter to his friend Hesse when he gave him one of the paintings from this series shows how much Purrmann had these connections in mind, especially since the protagonist in Hesse's story is also a painter.[38] The lost Italian paradise of the Villa Romana appears to have been reclaimed in the view of a largely empty room, one that simply features the free, serene interplay of the painting's radiant colours. With the wide-open glass doors that let in the sunlight, the view outside, the reflections of the sky in the windowpanes and the geometric planes of colour in the Baroque-framed mirror above the fireplace, Purrmann once again develops his inexhaustible play of visual relationships, down to the abstract planes reflected in the highly polished floor. Only on the balcony has Purrmann evoked a woman in a summer dress, "wholly imagined," as he wrote to Hesse, "without troubling a model."[39] In 1953 Hermann Hesse celebrated his painter friend, then aged 73, in his poem "An Old Painter in His Studio" (see page 77), in which he wrote of the "noble game" of his colours, how the artist translates what he sees into paint. Hesse's poem was a response to the interiors Purrmann had painted of the writer's former room.

In these years, encouraged by increasing success and recognition, Purrmann lived increasingly in his painting, but also in his memories: "Now I'm respected, almost famous, am assaulted, sell pictures, have virtually no time for myself, no longer work with the naïveté with which I worked then and which I sought. Now I have to stand my ground, have to fear the critics instead, for I'm in their sights," but "I'm virtually alone and live in my memories, without being able to form such valuable friendships any longer."[40]

In his determination to capture the reality he saw, Purrmann frequently painted a series of large-scale pictures devoted to one particular motif. In this he repeatedly emphasised that to him, each of these pictures was incomparable; that they were "naturally altogether different from each other."[41] This is the case with the self-portraits to which he devoted himself in Montagnola in 1952/53, a strikingly extended series of far more than ten works. In the *Self-Portrait* from 1953 (fig. p. 8), a block-like half-figure

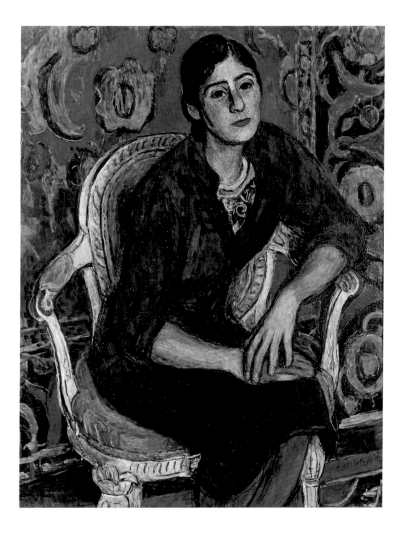

26 *Lady in a Green Dress, Indian Woman*, 1954
Oil on canvas, Sprengel Museum, Hannover

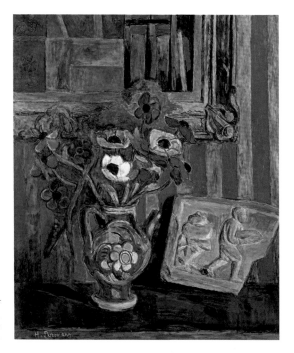

27 *Still Life with Relief in Front of a Mirror,* 1957, oil on canvas Private collection

portrait, composed with a severity commanding respect and distance, he emphasizes that he intended neither to flatter himself nor engage in brooding self-analysis. Placing himself in the centre of the picture, backed by framing stretchers turned to the wall, he portrays himself with the features of a worldly-wise 73-year-old, no longer particularly eager to make eye contact with viewers of his work. Purrmann occasionally painted self-portraits to give to acquaintances of his in Ticino, among them the art historian Gotthard Jedlicka.[42]

In 1954 he painted five different versions of a female portrait for which Fatima Goepfert served as model in rapid succession, one bearing the title *Lady in a Green Dress, Indian Woman* (fig. 26). Her father was of Indian extraction, which is why Purrmann chose the exoticizing description "Indian Woman." In each of his compositions he explored anew the relationship between figure and space. Here the young woman is seated in an elegant Baroque armchair in front of an antique Isfahan carpet, her dark green

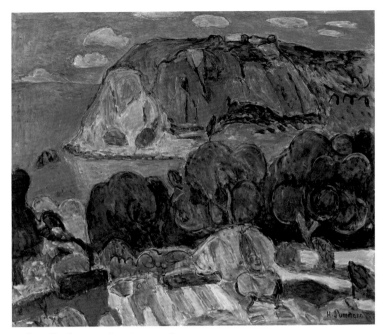

28 *Coastal Landscape near Lacco Ameno*, 1956
Oil on canvas, private collection

dress and earnest face framed with black hair, embedded in a sumptuous triadic harmony of the primary colours red, yellow-gold and light blue.

Purrmann also explored the motif pictured in *Still Life with Relief in Front of a Mirror* (fig. 27) in three different versions. The vase from his collection and the figural stone relief feature in his painting as virtual leitmotifs for decades. Here the familiar objects constitute an effective two-fold counterpoint to the strictly geometric stripes of the wallpaper and the reflection in the Baroque mirror, another picture-within-a-picture featuring the artist's easel and stretchers. Purrmann was a passionate collector of picture frames all his life. As Hugo Max has related, he would sometimes even create paintings specifically for empty frames he happened to have on hand.[43] Documentary photographs show that in such cases it was his practice to affix the canvas to the stretchers back-to-front, so that he had the particular frame constantly in mind while he worked. He could steady his

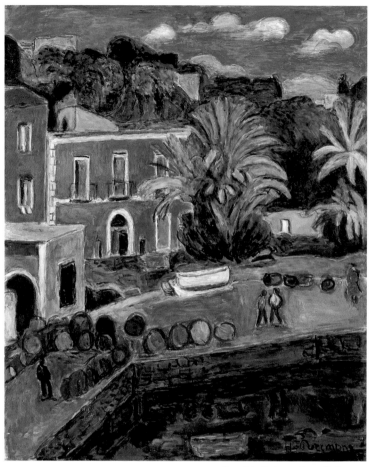

29 *Part of the Harbour at Porto d'Ischia*, 1961
Oil on canvas, private collection

free hand while his painting hand ranged across the surface, uniformly working toward the edges. After he had finished painting, he would finally tack the canvas onto the permanent stretcher, right side around.

Part of the secret of Hans Purrmann's art is that he adopted traditional studio practices and classical pictorial ideas – beyond the contemporary innovations by the various avant-garde movements – and adapted them to his own methods and colouring. Over decades, he developed a Modernist position that remains viable to this day. Even in his late work he was able to draw on the artistic legacy of Cézanne and Matisse to enrich his own painting in new ways, applying it to new motifs during summer stays on Ischia (1952–1958) and in Levanto (1963–1965). In the painting *Coastal Landscape near Lacco Ameno*, painted on Ischia in 1956 (fig. 28), he innovatively combined the tectonics of a Cézanne-like picture organisation with the sun-drenched colours of the Mediterranean. The play of glowing colours in *Part of the Harbour in Porto d'Ischia*, from 1961 (fig. 29), bustling with activity, is no less vivid.

When we look over Purrmann's shoulder as he paints in his Montagnola studio in a documentary film from 1962,[44] we can see how joyously he worked, with a keen eye and steady hand despite the physical limitations imposed on him by the stroke that confined him to a wheelchair in 1959. He appears to conjure the contours of his motif out of the blank white surface with light and provisional brushstrokes, as if succumbing for the first time to the fascination of a floral still life. His paints are neatly separated on his palette; he only mixes them on the canvas as he paints. We can easily follow the way in which he solidifies the geometry of his composition, working out the relationships between elements – even if he required an assistant during these years to shift the edges of the canvas within his reach. Still, Purrmann wields his brush with subtle, sovereign control while painting, so as to capture the separate delights of the objects before him.

From 1962 to 1965, he spent his summers at the Villa Le Lagore, near Levanto on the Ligurian coast. The paintings he made there explore the secluded motifs of an earthly paradise, just as before at the Villa Romana, and can rightly be seen as a peak in his late work, freely revelling in colours

31 *The Baroque Fountain in the Courtyard of the Villa Le Lagore*, 1963
Oil on canvas, private collection

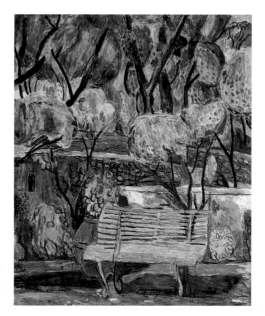

30 *Bench in the Courtyard
of the Villa Le Lagore*, 1962
Oil on canvas
Pfalzgalerie, Kaiserslautern

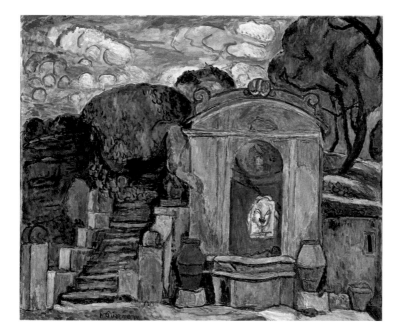

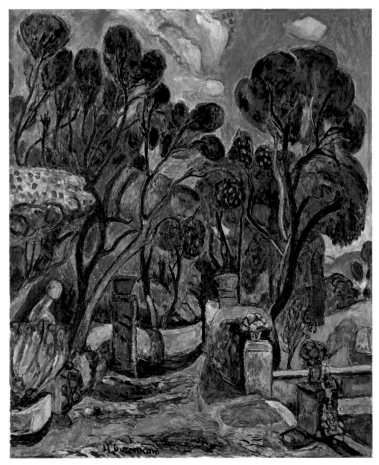

32 *Path Through the Park of the Villa Le Lagore*, 1964
Oil on canvas, private collection

and natural forms (figs. 30–33). In his painting *The Courtyard Chapel at the Villa Le Lagore* (fig. 33), he serenely captures the way in which the curves of the architecture resonated with the wisps of clouds in a seeming cosmic harmony.

An indication of Hans Purrmann's no-nonsense, unbending artistic nature is the fact that he remained committed to the principles he had internalised in his lifelong engagement with French art. Living in different countries,

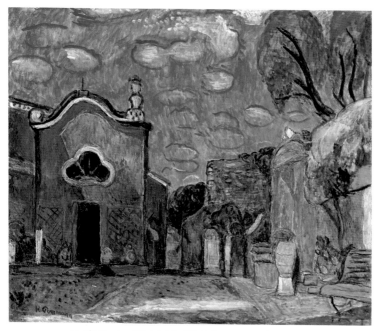

33 *The Courtyard Chapel at the Villa Le Lagore,* 1964, oil on canvas, private collection

he became an artist of European format at an early stage, one at home in the most varied cultural and artists' circles. Even today, the "grandeur of decor and colour judgement"[45] which he repeatedly developed in new form in his painting in these different locales, and which Werner Haftmann and Arnold Bode presented at *documenta I* as one position in contemporary art, is worthy of rediscovery.

CHRISTOPH WAGNER *holds the chair in Art History at the University of Regensburg and is an honorary member of the Academia Europaea (London). He has become internationally recognised for his research on the art of Modernism.*

1 Purrmann was referred to as a "classic" as early as 1950 by Heinz Braune and Edmund Hausen. See *Reden über Hans Purrmann*, ed. Friedrich Seel, Speyer 1996, pp. 20, 23. See also Edmund Hausen, *Der Maler Hans Purrmann*, Berlin 1950.

2 Hermann Hesse (1877–1962) in his poem dedicated to Hans Purrmann, "An Old Painter in His Workshop," from 1953. See page 77 in the present volume.

3 At *documenta I* the picture was shown under the title *Still Life with Fruits*; see *Katalog der documenta. Kunst des XX. Jahrhunderts. Internationale Ausstellung im Museum Fridericianum in Kassel*, exh. cat. Fridericianum in Kassel, Munich 1955, p. 57, cat. no. 541, fig. 15; in the catalogue raisonné it is now listed under the title *Still Life with Fruit and a Vase*; see Christian Lenz and Felix Billeter (eds.), *Hans Purrmann. Die Gemälde*, 2 vols., Munich 2004, vol. 2, 1955/13; cited in the following as WVZ (Werkverzeichnis).

4 Such is the note on a photograph of this painting in the Hans Purrmann Archiv, Munich.

5 WVZ *Gemälde*, vol. 1, 1903/06, p. 125. Letter from Purrmann to Braune, Stuttgart, 9 March 1904, Hans Purrmann Archiv, Munich.

6 Hans Purrmann, "Erinnerungen an meine Studienzeit" (1947), quoted from Barbara and Erhard Göpel, *Leben und Meinungen des Malers Hans Purrmann an Hand seiner Erzählungen, Schriften und Briefe*, Wiesbaden 1961, pp. 26–44, 39 f.

7 Hans Purrmann, "Versuch über Cézanne" (1960), ibid., p. 134.

8 Julius Meier-Graefe, *Paul Cézanne*, Munich 1910.

9 Hans Purrmann, "Einheit des Kunstwerks" (1949), quoted from Göpel 1960 (see note 6), p. 349. For the current state of scholarship, see Felix Billeter and Christoph Wagner (eds.), *Neue Wege zu Hans Purrmann*, Berlin 2016.

10 Cézanne in a letter to Joachim Gasquet from 26 September 1897; quoted from *Paul Cézanne: Über die Kunst. Gespräche mit Gasquet. Briefe*, ed. Walter Hess, Mittenwald 1980, p. 81.

11 See Lorenz Dittmann, "Hans Purrmanns farbige Bildgestaltung," in: *Hans Purrmann. 1880–1966. Im Raum der Farbe*, exh. cat. Historisches Museum der Pfalz, Speyer, ed. Meinrad Maria Grewenig and Lorenz Dittmann, Ostfildern-Ruit 1996, pp. 30–45; Gottfried Boehm, *Paul Cézanne. Montagne Sainte-Victoire*, Frankfurt am Main 1988.

12 See *Sehnsucht nach dem Anderen: Eine Künstlerehe in Briefen 1909–1914: Hans Purrmann und Mathilde Vollmoeller-Purrmann*, ed. Felix Billeter and Maria Leitmeyer, Berlin and Munich 2019. See also *Stürmische Zeiten: Eine Künstlerehe in Briefen 1915–1943: Hans Purrmann und Mathilde Vollmoeller-Purrmann*, ed. Felix Billeter and Maria Leitmeyer, Berlin and Munich 2020.

13 *Conversations with Cézanne*, ed. Michael Doran, Paris 1978, p. 36.

14 See Peter Kropmann, "Purrmann und Matisse: Netzwerke in Deutschland und Paris," in: Billeter and Wagner 2016 (see note 9), pp. 92–97.

15 See Ina Ewers-Schultz, "'Eine Art Universität': Purrmanns Pariser Jahre und die Bedeutung des Café du Dôme," in: Billeter and Wagner 2016 (see note 9), pp. 85–91; *Inspsiration Matisse*, ed. Peter Kropmanns and Ulrike Lorenz, Munich 2019; *Hans Purrmann: Kolorist der Moderne*, exh. cat. Kunsthalle Mannheim / Kunstforeningen GL Strand, Copenhagen / Kunsthalle Vogelmann, Heilbronn, ed. Annette Vogel, Munich 2019.

16 Karen Purrmann, "Hans Purrmann – Skulpturen und Zeichnungen," in: Billeter and Wagner 2016 (see note 9), pp. 109–117.

17 See Felix Billeter and Pia Dornacher, *Hans Purrmann: Handzeichnungen 1895–1966. Werkverzeichnis*, Ostfildern 2014; Christian Lenz and Felix Billeter, *Hans Purrmann: Aquarelle und Gouachen, Werkverzeichnis*, Ostfildern 2008; Angela Heilmann, *Das druckgraphische Werk. Gesamtverzeichnis*, Langenargen 1981.

18 WVZ *Gemälde*, vol. 1, p. 163.

19 Hans Purrmann, "Landschaften und Stilleben" (1961); quoted from Göpel 1961 (see note 6), p. 326.

20 Friedrich Rintelen, quoted from *Reden über Hans Purrmann* 1996 (see note 1), p. 12.

21 Hans Purrmann, "Landschaften und Stilleben" (1961); quoted from Göpel 1961 (see note 6), pp. 325 f.

22 See Erhard Göpel, "Purrmanns Kunsturteil," in: Göpel 1961 (see note 6), pp. 353–374.

23 See Göpel 1961 (see note 6), pp. 47, 82, 162 f., 178. See also Christoph Wagner, "'Mehr für die Wand als in den Händen anzusehen': Hans Purrmann und der deutsche Expressionismus," in: *Purrmann und die Expressionisten*, ed. Daniel J. Schrieber and Felix Billeter, Bernried 2017, pp. 62–69.

24 Hans Purrmann, "Landschaften und Stilleben" (1961), in: Göpel 1961 (see note 6), p. 325.

25 See Clemens Jöckle, "Spiegel und Trompe-l'Oeil – zur Kontinuität der Bildmotive im Werk Hans Purrmanns" (1992), in: *Reden über Hans Purrmann* 1996 (see note 1), pp. 226–235. See also Christian Lenz in: *Hans Purrmann. "Im Kräftespiel der Farben." Gemälde – Aquarelle*, exh. cat. Kunsthalle Tübingen and elsewhere, ed. Christian Lenz, Munich 2006, p. 120.

26 Jedlicka (1962), quoted from *Reden über Hans Purrmann* 1996 (see note 1), p. 45.

27 Quoted from *Reden über Hans Purrmann* 1996 (see note 1), p. 192.

28 See Philipp Kuhn, *Refugium Villa Romana. Hans Purrmann in Florenz. 1935–1943*, Munich 2019.

29 Politisches Archiv des Auswärtigen Amtes, German Embassy Rome (Quirinal), Villa Romana Florenz, WO 7 1379 D.

30 Adolf Leisen, "Zum 125. Geburtstag des Malers – Purrmann und seine Freunde," in: *Kunstportal Pfalz*, 10 April 2005.

31 See Thomas Föhl and Gerda Wendermann (eds.), *Ein Arkadien der Moderne? 100 Jahre Künstlerhaus Villa Romana in Florenz*, Berlin 2005.

32 Werner Haftmann, *Verfemte Kunst. Bildende Künstler der inneren und äusseren Emigration in der Zeit des Nationalsozialismus*, Cologne 1986, pp. 138 f.

33 Ibid., p. 137. See also Kuhn 2019 (see note 28), p. 152.

34 Lenz 2006 (see note 25), pp. 168, 216.

35 WVZ *Gemälde*, vol. 2, p. 71, no. 1940/18.

36 Hans Purrmann, *Self-Portrait*, 1940/32, 78 × 64 cm, whereabouts unknown.

37 Hermann Hesse, *Klingsors letzter Sommer*. Erzählungen, Berlin 1920.

38 Letter from Purrmann to Hesse from 12 July 1952; quoted from *Reden über Hans Purrmann* 1996 (see note 1), p. 244. See also *Hermann Hesse – Hans Purrmann: Briefe 1945–1962*, ed. Felix Billeter and Eva Zimmermann, Berlin 2011. The painting given to Hesse with the dimensions 26 × 34.5 cm is now in the Hermann-Hesse-Museum, Calw.

39 Letter from 12 July 1952; quoted from WVZ *Gemälde*, vol. 2, p. 172.

40 Hans Purrmann, letter to Elfriede Haarmann, 5 April 1957; quoted from Göpel 1961 (see note 6), p. 305.

41 Hans Purrmann, letter to Hesse; quoted from *Reden über Hans Purrmann* 1996 (see note 1), p. 244.

42 Billeter and Wagner 2016 (see note 9), p. 285.

43 Hugo Max, "Mit Hans Purrmann in Florenz – Episodisches," in: *Hans Purrmann. Zum 100. Geburtstag*, exh. cat. Museum Langenargen, Langenargen 1980, p. 110.

44 Film by Günther Bekow, *Hans Purrmann in seinem Atelier*, Montagnola 1962 (https://doi.org/10.3203/IWF/G-94 [accessed 12 February 2021]).

45 Werner Haftmann, "Erinnerungen an Hans Purrmann"; quoted from *Reden über Hans Purrmann* 1996 (see note 1), p. 155.

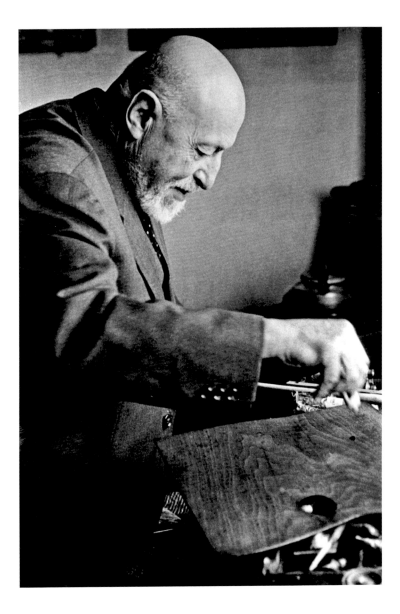

34 Hans Purrmann in his studio, 1957

BIOGRAPHY

Hans Purrmann
1880–1966

1880–1897 Hans Marsilius Purrmann is born in Speyer on 10 April 1880 as the first son of the craftsman painter Georg Purrmann (1846–1900) and his wife Elisabeth (1848–1916). He will be followed by a brother, Heinrich Christian (1881–1943), and a sister, Friederike (1884–1963). He will stay in loving contact with both of his siblings all his life; Heinrich will take over his father's shop in 1900, thus freeing Hans from the traditional obligation of the first-born. Following his grammar school years (1886–1893), which Hans found "painful," he undergoes training in decorative painting (1893–1897) in his father's shop, along with studies at Karlsruhe's school of arts and crafts. His beginnings in an artisanal painting business will be an important element of his biography as he sets out into the art world: from his earliest years Hans Purrmann is a painter and artist who devotes himself to art with neither academic pretensions nor cultured-middle-class notions. The practical grounding of his art in painting grants him access to important painters in the most varied European art centres over the course of his life.

1897–1905 In October 1897 Purrmann begins his studies at Munich's Academy of Fine Arts and enrols in Gabriel von Hackl's drawing class and Franz von Stuck's class in painting. A number of his fellow students will become famous, among them Paul Klee, Wassily Kandinsky and Albert Weisgerber. Beginning in 1903, Purrmann repeatedly participates in the Munich Secession's spring exhibitions, and early on such art critics as Karl Voll, Friedrich Rintelen and Heinz Braune take note of the young artist's talent. A short stay in Berlin brings him into contact with Heinrich Zille, the art dealer Paul Cassirer and the artist Max Liebermann. Liebermann smooths his way into the Berlin Secession.

1905–1912 A crucial new stage in Purrmann's life begins when he moves to Paris in November 1905. Here he receives artistic impressions that will stay with him all his life and makes important decisions. In the famous Café du Dôme he comes into contact with countless artists from the German and French avant-garde movements of his time, meets collectors and art dealers like Karl Ernst Osthaus and Alfred Flechtheim as well as critics like Julius Meier-Graefe. He is able to study current trends in French painting in major exhibitions, including the work of Édouard Manet, André Derain, Paul Cézanne and Henri Matisse. For Purrmann, as for

35 Hans Purrmann, c. 1900

36 Hans Purrmann and Eugen Kahler, Svinar, 1903

37 Hans Purrmann (3rd from right) with Matisse (2nd from right) and members of the Académie Matisse, Paris, 1909

many other artists, the famous Cézanne memorial show in the 1907 Autumn Salon is a key experience. Of greatest influence at this time is his increasing artistic engagement with Henri Matisse, whom he comes to know in 1906 by way of the family of Sarah Stein. In these years – namely in June 1908, winter 1909/10 and October 1910 – Purrmann repeatedly travels with Matisse to Germany, hoping to make the older man's work better known there. On painting trips to the picturesque coastline of the Calanques near Cassis in the summer of 1909, along the Côte Vermeille near the fishing village of Collioure north of the Pyrenees in the summer of 1911, and to Ajaccio on Corsica in 1912, all in search of the southern light, Purrmann develops stroke by stroke, stimulated by the colouristic potential of the painting of Cézanne and Matisse. He also makes his first experiments with the art of sculpture. In the years 1908 to 1911, as co-founder and chairman of the Académie Matisse, a private painting school, he works to establish Matisse's art in France as well, and soon comes to be known, pejoratively, as a "German Matisse." Only a short time later he will be vilified by his countrymen as a "would-be Frenchman."

1912–1914 As early as 1906, Purrmann had made the acquaintance of the artist Mathilde Vollmoeller (1876–1943), who is wildly successful at the Autumn Salon exhibitions in these years. She has a studio near his in the Rue Campagne Première. The daughter of a Swabian merchant and textile manufacturing family known worldwide for its knitwear, including Reform-minded underwear and rayon, Mathilde Vollmoeller is just as determined in her devotion to fine art, especially painting, as Purrmann himself. For many years she has maintained a correspondence with Rainer Maria Rilke, and thanks to her fluent French she frequently serves as a mediator between German and French artists. Her encounter with the painting of Cézanne in 1907 had been as decisive an experience for her as it was for Purrmann. In 1908 she attends the Académie Matisse, so it was only natural that Mathilde Vollmoeller and Hans Purrmann should establish a personal relationship. In October 1911 the two had decided to marry, and their wedding takes place a few weeks later, on 13 January 1912, in Stuttgart. During their honeymoon in Ajaccio, on Corsica, they create paintings on identical motifs. In September 1912 their daughter Christine (1912–1993) is born at Burg Hohenbeilstein, the Vollmoeller family seat above the town of Beilstein, near Heilbronn in Baden-Württemberg.

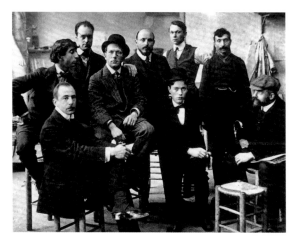

38 Members of the Académie
Matisse (Purrmann at centre),
Paris, c. 1920

39 Hans Purrmann,
Albert Weisgerber and
Henri Matisse (left to right) in
Munich's Löwenbräukeller, 1910

40 Hans Purrmann in the circle
of the Matisse family, 1911

1914–1916 In January 1914 their son Robert (1914–1992) is born in Paris. Their plan to establish a permanent residence there is foiled by the outbreak of the First World War. Owing to a nervous disease, the so-called Rothmund-Thomson syndrome, Purrmann is exempted from military service. The couple's Parisian apartment is confiscated along with their considerable art collection, and until the end of 1915 they live at Hohenbeilstein. Only years later, in 1920, will Mathilde Vollmoeller-Purrmann manage to retrieve some of the works of art from their Parisian collection. Much of it will be auctioned without their knowledge in Paris in 1921/22. Their daughter Regina (1916–1997) is born at Hohenbeilstein in September 1916.

1916–1919 Prevented from returning to Paris during wartime, Purrmann develops wide-ranging networks in the Berlin art scene. Since 1915 he has regularly shown his work in exhibitions by both the Freie Secession and the Berlin Secession. At the beginning of 1916 he moves his family to Berlin and establishes a studio there. One of the highlights of his early reception in Berlin is the one-man show, complete with an illustrated catalogue, that Paul Cassirer presents in his gallery in June/July 1918. Recommended by Max Liebermann and Max Slevogt, Purrmann is inducted into the Prussian Academy of Arts in March 1919. Increasing interest in Purrmann's painting is reflected in numerous mentions of him in art-historical literature.

1919–1922 As a rural alternative to his Berlin headquarters, in October 1919, the Purrmanns purchase a fisherman's house in Langenargen on Lake Constance, where they will regularly spend their summers until 1935. In June 1920 Purrmann journeys to Rome with Heinz Braune and Paul Cassirer, and in the summer of 1922 with his family to Sorrento, on the Gulf of Naples, to which he will return repeatedly in the following years. The newly acquired Italian motifs appear frequently in his art.

41 Mathilde Vollmoeller, 1898

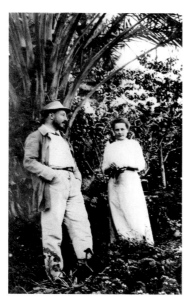

42 Hans Purrmann with
his wife on Corsica, 1912

43 In his studio in Berlin, 1919

1922–1927 Purrmann spends the summer months in Langenargen on Lake Constance and the winter months in Italy. During his stays in Rome, Sorrento, Venice and Naples he produces numerous drawings, watercolours and paintings on Italian motifs, as well as copies of old masters. Important one-man shows are presented in Basel in 1925, in Kaiserslautern in 1927 and in Nuremberg in 1928.

1927–1935 In 1927 Purrmann returns to Berlin and takes an apartment above the Galerie Alfred Flechtheim on the Lützowufer. In 1929 he suffers a serious bout of typhus. For his 50th birthday in April 1930 the Reich Interior Ministry awards him an honorary prize. In 1931 he is given a public commission, the design of a wall painting for the District Council Hall in Speyer, for which he completes a large-format triptych picturing an allegory of the Arts and Sciences in 1932. But meanwhile, social conditions in Germany have changed following the right-wing, conservative shift that will lead to National Socialism. The distinctly liberal political iconography of his painting immediately provokes defamatory reactions. Purrmann's ability to make a living as a painter in Germany becomes increasingly difficult. With the National Socialist takeover it becomes virtually impossible for him to exhibit his work. In November 1934 Purrmann travels to Paris, largely in order to see Henri Matisse again. On 11 February 1935, he is among the few mourners present at Max Liebermann's funeral in Berlin's Jewish Cemetery.

1935–1943 Purrmann is reviled by the National Socialists as a "would-be Frenchman" and protégé of Jewish art dealers, and is henceforth treated as a "degenerate" artist. His works, considered inimical to National Socialist cultural policy, are shown in the *Degenerate Art* exhibition in 1937 and a total of 45 works of his are removed from German museums. The fact that he is nevertheless able to accept the Villa Romana Association's invitation to serve as director of that institution, respected by the National Socialists, is one of the anomalies in the art world in these years. During a visit to Florence by Adolf Hitler in 1938, Purrmann is detained for a few days. Aside from that, he is able to travel during these years and even to mount a few exhibitions. Study trips in the years 1937–1940 take him to Castglion-cello, Siena, Lerici and Trento.

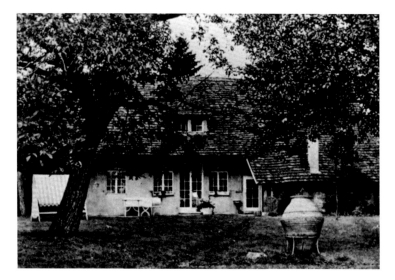

44 The fisherman's house at Langenargen purchased by
Hans Purrmann in 1919, Hans Purrmann Archiv, Munich

45 In the garden of the house at Langenargen, 1931
(left Hans Purrmann, right Eugen Spiro), Hans Purrmann Archiv, Munich

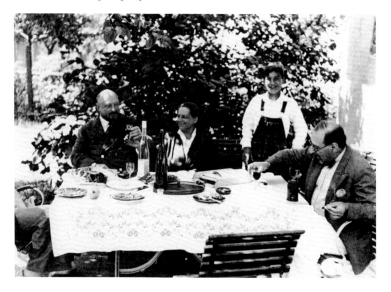

On 16 July 1943, Purrmann's wife Mathilde dies in Munich after a serious illness, and at nearly the same time his situation in Italy becomes no longer tenable. In view of the approaching military action, he is forced to hastily flee from Italy in the autumn of 1943 and is taken in by relatives of his deceased wife living in Zürich. His work of art and other possessions are left behind for many years, but he is later able to reclaim them with great effort.

1944–1949 Purrmann first lives in the Hotel Bellavista in Montagnola, on the Collina d'Oro above Lugano. He there becomes acquainted with the textile artist and tapestry weaver Maria Geroe-Tobler (1895–1963), who introduces him to Hermann Hesse. In 1948 Purrmann finds a new place to live and work in an apartment in the Casa Camuzzi, where Hermann Hesse had also lived until 1931.

1950–1959 On the occasion of his 70th birthday the city of Speyer awards Purrmann honorary citizenship. Important retrospectives of his work are mounted at the Kunstmuseum Luzern and at the Pfalzgalerie Kaiserslautern, and subsequently travel to other venues in Speyer, Mannheim, Stuttgart, Munich, Hamburg, Bremen and Bochum. In 1951 Purrmann is named a corresponding member of the Bavarian Academy of Fine Arts in Munich. After many years he sees Henri Matisse for a last time in 1961 at the consecration of the Matisse Chapel in Vence. Several trips to Italy, especially Ischia, beginning in 1953, take him to places he had frequented back in the 1920s. Hans Purrmann's inclusion in *documenta I* in Kassel in 1955 amounts to a virtual accolade, for with it his figural, representational painting finds its place among the internationally important avant-garde positions of post-war art. Along with many other honours in these years, he is awarded the order Pour le Mérite by Federal President Theodor Heuss – who had become personally acquainted with Purrmann back in his Parisian years. With remarkable vitality, Purrmann engages in countless activities – travels, juries and exhibitions – in addition to his painting. But all this abruptly ends in 1959, when he suffers a stroke during a stay at the Villa Massimo in Rome that will confine him to a wheelchair for the rest of his life.

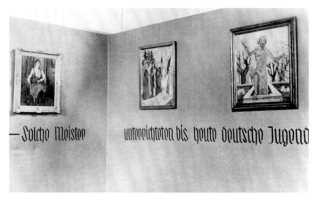

46 A Purrmann painting (on the left) at the *Degenerate Art* exhibition in Munich, 1937

47 With his daughter Regina in Florence, c. 1938

1960–1965 Despite his physical impairment, in Purrmann's late years he continues his artistic work in his studio next to the Casa Camuzzi. He regularly spends the summer months in Levanto, near La Spezia on the Ligurian Coast. Evidence of his growing artistic reputation are the retrospective held at the Kunstverein Hannover in 1960, which includes 168 paintings and graphics, and the monograph published by Barbara and Erhard Göpel in 1961. Another widely reviewed retrospective is presented in 1962 at the Haus der Kunst in Munich, which then travels to Baden-Baden and Frankfurt am Main. France awards him the honour "Officier de l'Ordre des Arts et des Lettres de la République Française," distinguishing him not only as a "German Matisse" but also as an artist of European format.

1966 A lung infection early in the year ushers in the final phase of his life. He dies in Basel on 17 April, and on 22 April, he is buried next to his wife Mathilde Vollmoeller-Purrmann in Langenargen. It is reported that his last words were related to painting: "Portami i colori!—"Bring me my colours!"

48 Hans Purrmann in
the Villa Romana, 1941

49 Hans Purrmann in his studio in Montagnola, 1950s

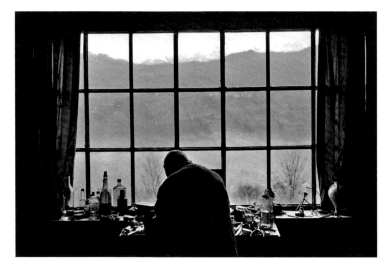

Self-Portrait in Front of Speyer Cathedral, pencil, ink, gold pigment and photogravure in blue, 13.9 × 9 cm, postcard from Hans Purrmann to Karl Krömer, postmarked: Munich, 13 January 1899, private collection

ARCHIVE

Finds, Letters, Documents
1899–1953

I

I

With sassy wordplay and in a self-assured photographic attitude, the 18-year-old Purrmann presents himself to his boyhood friend from Speyer on this New Year's card he made himself. Purrmann's report as a brand new "academic" from his first days as a pupil, shortly after passing the entrance exam and matriculating at the Munich's Academy of Art, is overflowing with joie de vivre: I'm happy to be an academic, life as such is wonderful, every evening I regret that the day is over! *The cautiously malicious gaze of his "first model," whom he portrayed in soft pencil strokes on this postcard, hardly suggests that over the next sixty years Purrmann would make more than 700 drawings after nude models.*

I *My First Model*, pencil, 14 × 9 cm, postcard from Hans Purrmann to Karl Krömer, postmarked: Munich, 13 November 1897, private collection

2a, b

2

Hans Purrmann repeatedly took painting trips with Henri Matisse to France's southern Atlantic coast, as in the summer of 1910 to the picturesque Côte Vermeille. Matisse excitedly lured Purrmann, who was still in Paris, to the fishing village Collioure: Je suis enchanté de mon séjour ici, tout va bien et il n'y a rien de vrai comme une bonne retrempe de nature amicalement H.M. (I am delighted by my stay here. Everything is as it should be and there is nothing better than rest and recuperation in nature. Best wishes H.M.)

2 Postcard from Henri Matisse to Hans Purrmann, Collioure, 1910, Hans Purrmann Archiv, Munich

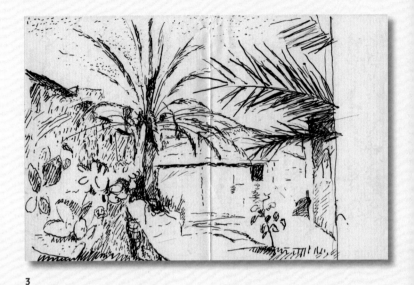

3

3

Purrmann and Mathilde Vollmoeller candidly and earnestly related their artistic impressions and experiences to each other before deciding in October 1911 to marry as soon as possible.

As I already said, it is very beautiful here, though I wouldn't mind looking for other spots, Matisse has done what was possible here and it takes away from the freedom somewhat. ... I have here made a drawing of the palm tree I am painting just now. ... The palm is loaded with ripe dates! The whole bathed in light! Today I have a slight headache and little desire to do anything! Write to me, tell me about yourself and your surroundings, I treasure every word, affectionately, your Purrmann.

3 *Palm in Collioure*, letter to Mathilde Vollmoeller from 25 July 1911, Hans Purrmann Archiv, Munich

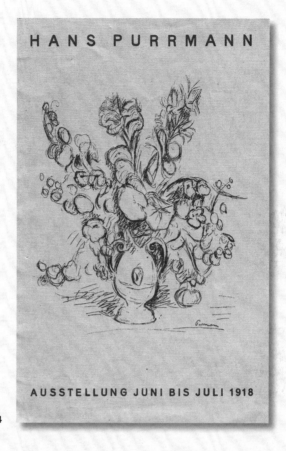

HANS PURRMANN

AUSSTELLUNG JUNI BIS JULI 1918

4

4

A first one-man show with a published catalogue at the Galerie Paul Cassirer in Berlin in the summer of 1918 was tantamount to an accolade for Hans Purrmann. But this event had another side to it: Early on, Paul Cassirer had supported the gifted but destitute young artist for a time with monthly advances during his Parisian years. In return, Purrmann presumably sent his pictures to Cassirer, who could then sell them.

4 Cover of the catalogue of the exhibition at Cassirer's, Berlin,
June–July 1918

Alter Maler in der Werkstatt
Hans M. Purrmann in Freundschaft gewidmet·

[poem in handwritten script]

Hermann Hesse
(1953)

11

5

5

*In Montagnola, Hans Purrmann and Hermann Hesse were on friendly terms
as neighbours and like-minded contemporaries. In 1953, after one of their re-
ciprocal visits, Hesse penned a poetic monument to his painter friend, then*

5 Hermann Hesse (1877–1962), illustrated typeset of his poem
"An Old Painter in His Studio. Dedicated to Hans M. [Marsilius]
Purrmann in friendship," with autograph date and signature
"HHesse," 1953, 21 × 15 cm, Hans Purrmann Stiftung, Munich

aged 73, in "An Old Painter in His Studio." In it, his observations of the "noble game" of colours, of "balance" and "harmony" in the "interplay of colours" are key motifs. The illustration attached to the poem pictures Purrmann's studio with its large atelier window, a self-portrait on the easel and a vase of flowers arranged for a still life.

An Old Painter in His Studio

December light falls from the large window
Onto blue linen, rose damask,
A gilt-framed mirror talks to the sky,
A blue-bellied earthenware jug embraces the bouquet of flowers,
Multicolored anemones, yellow cresses.
In their midst, engrossed in his game,
Sits the Old Master, painting his own countenance
In the way that the mirror reflects it back to him.
Perhaps he began for his grandsons.
A testament, maybe seeking a trace of his own youth
In the mirror's glass. But that is long forgotten.
That was just a whim, just a prompt.
What he sees and paints isn't himself; he carefully ponders
The light on his cheek, forehead and knee, and the blue
And white in his beard; he makes his cheeks glow
And flower-pretty colors blossom out of the gray
Of the drapes and his old jacket,
He hunches his shoulders, exaggerates the size
Of his rounded skull and gives his full mouth
A tinge of carmine. Engrossed in this noble game
He paints as if he were painting air and mountains and trees,
Paints his likeness into imaginary spaces
Like it was anemones or cress,
Caring about nothing except the balance
Of red and brown and yellow, the harmony
In the interlay of the colors that radiates
In the light of the creative moment, beautiful as never before.

SOURCES

PICTURE CREDITS

All photos in this volume were graciously provided by the Hans Purrmann Archiv in Munich.

SOURCES

Barbara and Erhard Göpel, *Leben und Meinungen des Malers Hans Purrmann an Hand seiner Erzählungen, Schriften und Briefe*, Wiesbaden 1961
Christian Lenz and Felix Billeter (eds.), *Hans Purrmann. Die Gemälde*, 2 vols., Munich 2004
Felix Billeter and Christoph Wagner (eds.), *Neue Wege zu Hans Purrmann*, Berlin 2016
Christoph Wagner, "Hans Purrmann und die Lehre Paul Cézannes: ein Leben in Farbe", in: *Hans Purrmann. Ein Leben in Farbe*, exh. cat. Kunstforum Hermann Stenner, Bielefeld, ed. Felix Billeter, Christiane Heuwinkel and Christoph Wagner, Munich 2021, pp. 46–59.

The poem "An Old Painter in His Studio" (p. 77) is a text excerpt taken from: *Hesse: The Wanderer and his Shadow* by Gunnar Decker, translated by Peter Lewis, Cambridge, Mass.: Harvard University Press, pp. 390–391, Copyright © 2018 by the President and Fellows of Harvard College

The author wishes to thank the Hans Purrman Archiv, and especially Dr. Felix Billeter, for their support. The archive was established and expanded by Robert Purrmann, the artist's son. After his death in 1992 his work was continued by his wife Mechthild Purrmann. Since 2008 it has been housed in Munich's Museum Quarter and is now supported by Robert Purrmann's heirs and overseen by Felix Billeter and Julie Kennedy.

Published by
Hirmer Verlag GmbH
Bayerstraße 57–59
80335 Munich
Germany

Cover illustration: *Interior with a Girl in a Deck Chair* (detail), 1928, see p. 33
Double page 2/3: *Path Through Olive Trees* (detail), 1922, see p. 27
Double page 4/5: *Path Through the Park of the Villa Le Lagore* (detail), 1964, see p. 52

© 2021 Hirmer Verlag GmbH, the author

All rights reserved.

No part of this book may be reproduced or transmitted in any form or by any means, electronic or mechanical, including photo-copying, recording or any other information storage or retrieval system, without prior permission in writing from the publisher. The work may only be reproduced – in whole or in part – with the permission of the publishers.

www.hirmerpublishers.com

TRANSLATION
Russell Stockman

COPY-EDITING
Jane Michael, Munich

PROJECT MANAGEMENT
Tanja Bokelmann, Munich

GRAPHIC DESIGN AND PRODUCTION
Marion Blomeyer, Rainald Schwarz, Munich

PRE-PRESS AND REPRO
Reproline mediateam GmbH, Munich

PRINTING AND BINDING
Passavia Druckservice GmbH & Co. KG, Passau

Bibliographic information published by the Deutsche Nationalbiliothek. The Deutsche Nationalbibliothek lists this publication in the Deutsche Nationalbibliografie; detailed bibliographic data is available on the Internet at http://dnb.d-nb.de.

ISBN 978-3-7774-3679-1

Printed in Germany

THE GREAT MASTERS OF ART SERIES

ALREADY PUBLISHED

WILLEM DE KOONING
978-3-7774-3073-7

LYONEL FEININGER
978-3-7774-2974-8

PAUL GAUGUIN
978-3-7774-2854-3

RICHARD GERSTL
978-3-7774-2622-8

JOHANNES ITTEN
978-3-7774-3172-7

VASILY KANDINSKY
978-3-7774-2759-1

ERNST LUDWIG KIRCHNER
978-3-7774-2958-8

HENRI MATISSE
978-3-7774-2848-2

PAULA MODERSOHN-BECKER
978-3-7774-3489-6

LÁSZLÓ MOHOLY-NAGY
978-3-7774-3403-2

KOLOMAN MOSER
978-3-7774-3072-0

ALFONS MUCHA
978-3-7774-3488-9

EMIL NOLDE
978-3-7774-2774-4

PABLO PICASSO
978-3-7774-2757-7

HANS PURRMANN
978-3-7774-3679-1

EGON SCHIELE
978-3-7774-2852-9

FLORINE STETTHEIMER
978-3-7774-3632-6

VINCENT VAN GOGH
978-3-7774-2758-4

MARIANNE VON WEREFKIN
978-3-7774-3306-6

www.hirmerpublishers.com